Walking the Dog in Italy

Gail Donovan, Simon Griffiths & Danie Pout

VIKING

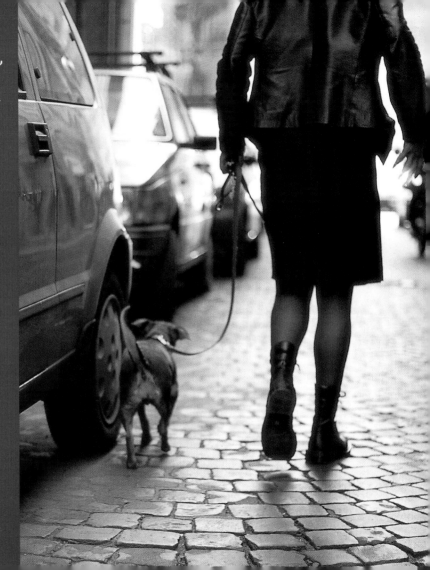

To our beautiful dogs– Gable Donovan, the standard poodle, and Master Massimo, the wonderful Whippet

Their friends – Chanti, Miss Maddie, Pixie Anne, Fritzie, Simon, Eileen + Peg, Jake, Jasper, Spannie, Sootie, Ruben + Max

OUR THANKS TO:

🐾 Kevin Donovan for his tireless support and research

🐾 Julie Gibbs at Penguin Books for her endless enthusiasm

🐾 Kirsten Abbott at Penguin Books –our editor

🐾 Manuela Hillary + her husband, Simone, for all their hard work and friendship in Italy despite the events of 11 September

🐾 Sandra Boyle at Dogs of Victoria Obedience School

🐾 Judy Gillard Travel

🐾 Sally Titcomb translation services

🐾 Pamela Pavitt at British Airways

🐾 Liz Young at Qantas Airways

🐾 Allison, Bob & Alexandra Cameron and their beautiful standard poodles

🐾 Vicki Scott-Murphy for all the typing

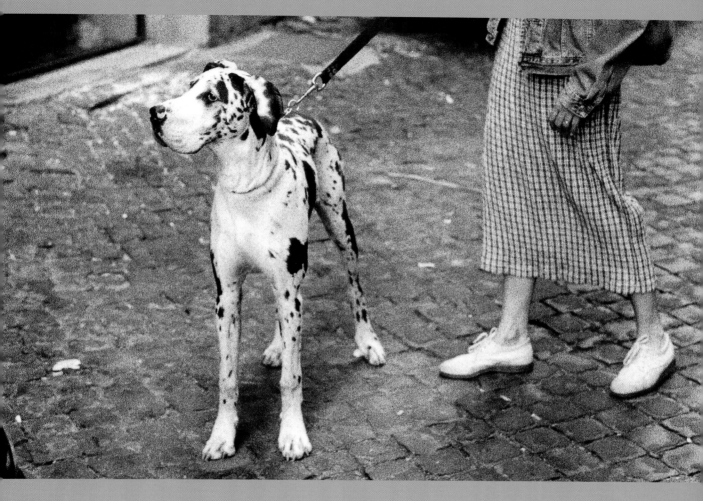

In memory of the late Beau Donovan, who was the inspiration for Marco

Trappa

Toto

Cedro

Stone + Perela

Akira

Nerina + Schnitz

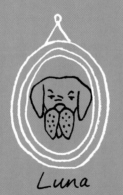

Luna

Carlotta

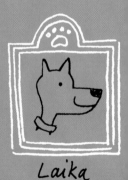

Laika

Grazie tante – to all of Marco's friends who

Tsasko

Vic

Toni

X and Big

Kali + Schif

Willy

Digging Dog

Gin

Max

Picasso

made WALKING THE DOG IN ITALY such fun

Hi everyone — Ciao tutti. Allow me to introduce myself. I'm Marco, your guide in Italy. It's my job to introduce you to all my doggie friends: the Roman donnas, the slinky Sicilians, dogs big and small, well-bred and street-wise, spoiled and fun-loving — all with a story to tell. You'll also meet their human companions and hear about the dogs' likes and dislikes, favourite places and good and bad habits. Italian dogs in general (in my opinion) are very much like their companions — outgoing, fashion-conscious and fanatical about food. In fact, they are obsessed with what they eat. Me, I eat everything. I'm the doggie gourmet of Italy, and proud of it. I also love adventure. I love to travel and I love other dogs. So come with me on my journey through Italy, meet my doggie friends and their companions and be Italian for a while.

Ciao tutti

Marco One of Marco's friends One of Marco's companions

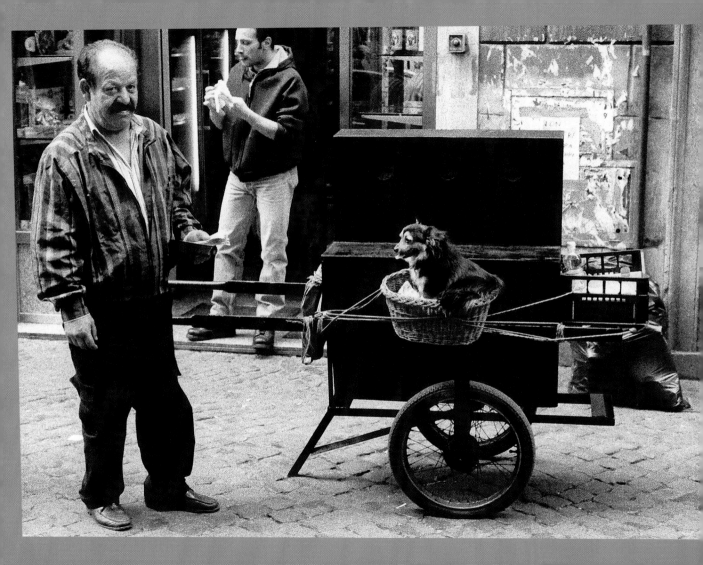

Before any walk, a dog needs to show he or she is ready. A good friendly sit beside the companions you love is a great way for any dog to start. In Italy this usually results in an instant reward of food. There's always a good chance of a hug, kind words and more food with the sit. Most of my friends do their best sit and loving stare outside the gelati, cheese or local butcher's shop. It can work miracles. It is also good to sit before you put a paw onto any of Italy's streets. Those people just can't drive! That of course is my opinion only. Let's sit and see.

sit

seduto

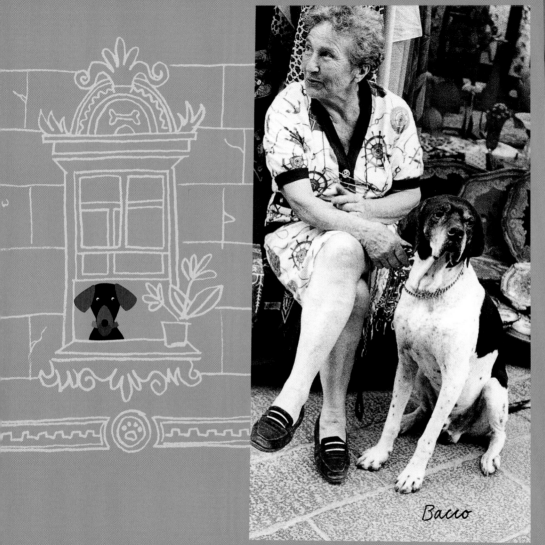

Bacco

Olivia

Ulisse

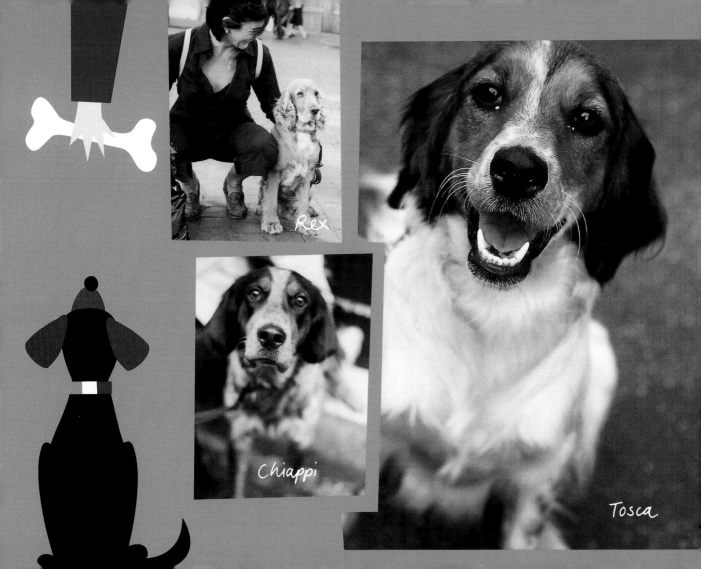

Rex

Chiappi

Tosca

Dogs that sit get praise, pats, kisses, food, friends & stay safe

Trappa + Laura
Sit for treats

There's no better way to make a dog sit than to sit right down beside it. These two, Trappa and Laura, have the right idea. Every morning after a coffee stop, they head for the park to sit on their favourite bench together, taking in the sun, watching passers-by and chatting to everyone, including me, Marco. *Stupendo!* So Italian! There's Trappa, combination of German shepherd and chow (some dog!), on the bench with the lovely Laura. Does it bother me that Trappa towers over me while I sit patiently on the ground? Not at all! I sit because I'm supposed to, but a dog will do anything for treats. Laura is a great cook. She makes the best dog treats I've ever tasted. (I love food, have I told you?) *Grazie*, Laura!

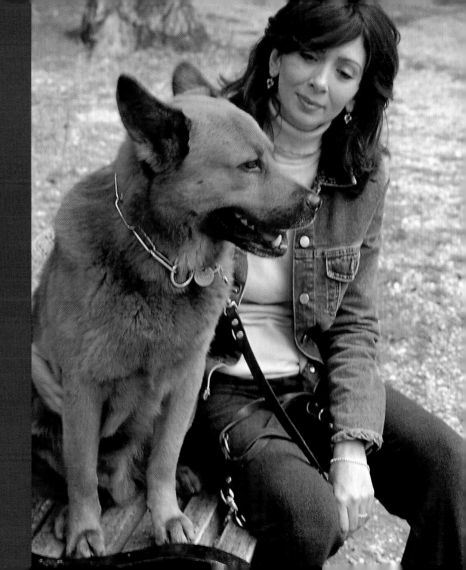

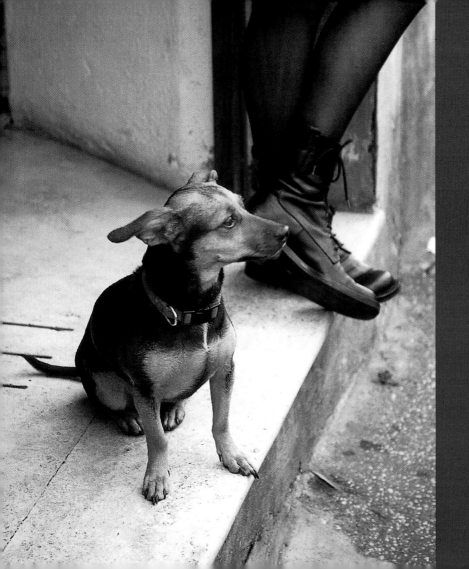

LAURA'S LIVER TREATS
For dogs that sit

chicken livers, cleaned of fatty veins
 (as desired)
garlic powder (to dust)

1. Wash livers in cold water and place them in a saucepan with enough water to cover. Bring to a boil and simmer for 4 minutes. Drain and cool.

2. Preheat oven to 120°C. Cut liver into bite-sized pieces and arrange on a baking sheet lined with baking paper. Place liver in the oven for 1½–2 hours until they are dried out.

3. Liberally dust liver pieces with garlic powder and store in an airtight container in the refrigerator. The treats will last several weeks.

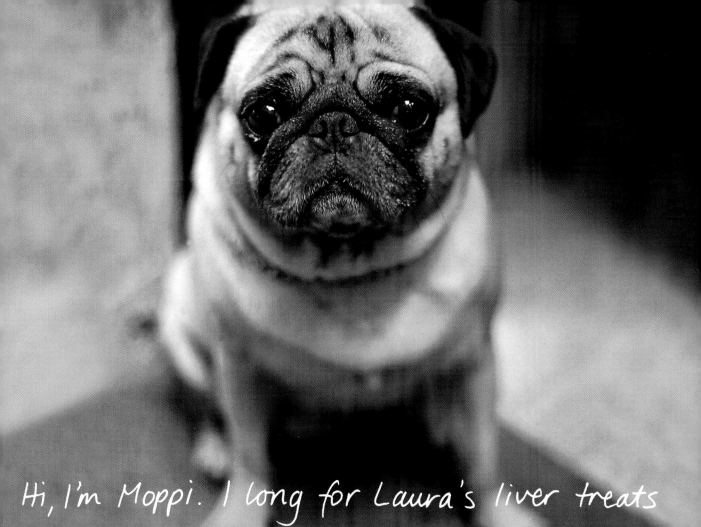

Hi, I'm Moppi. I long for Laura's liver treats

Max + Mr Business

Sit + watch the world go by

I met Max and his companion, Mr Business, in the Villa Borghese gardens – where else? You know the kind: the perfect crease in the trousers, the jacket and, of course, the designer tie and shoes. (I can spot a pair of Gucci loafers 10 metres away.) Oh, and the mobile phone buzzing in the pocket. I don't know how Max takes it. It must be the months and months he spent at dog school. Mr Business wanted a well-trained dog. The teacher did a great job. However, Max, like some of his other Italian friends, just hates to sit on the ground. Every chance he gets he sits on the bench. I'd never do that. I don't get it! I like it on the ground. All those smells, shoes, trees and plenty of great places to sit. Who needs a bench? Not me.

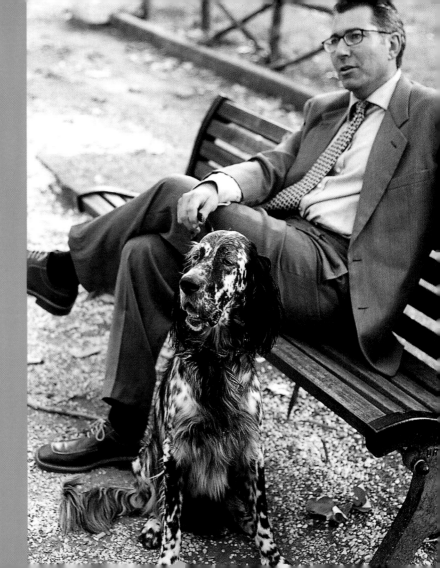

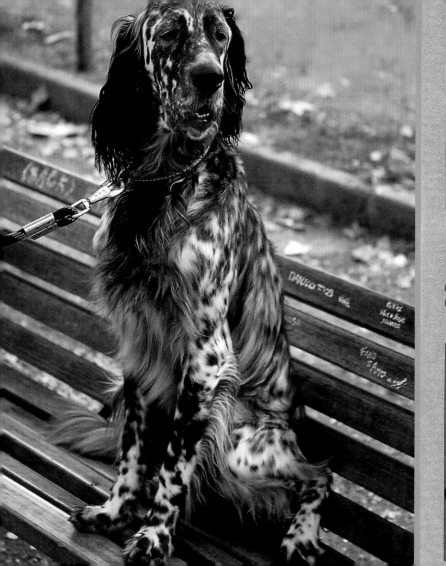

 non sporco la città

manici a paletta in cartone

I ♥ MY DOG®
Patent Pending
Registered Model

NON SPORCO LA CITTÀ

Sacchetto igienico
tascabile per raccogliere

Laika

Sit in a bucket

Ah, *bella* Laika, the wonder dog. Her family run one of the market stalls in the Campo de' Fiori, directly opposite the butcher's shop. Laika doesn't sit for treats looking cute like most dogs. She's too smart. Hers is the 'sit in the bucket' trick. She taught herself how to do it. Why just sit on the pavement waiting for food when sitting in a bucket brings everyone running? I can hear them now: 'Oh, she's so cute', 'Look, she's in a bucket', 'She's sitting so still'. On and on it goes. I don't get any attention. I wish someone would give me a bucket. Laika is named after the first dog in outer space – perfect for a smartie like her. *Brava*, Laika.

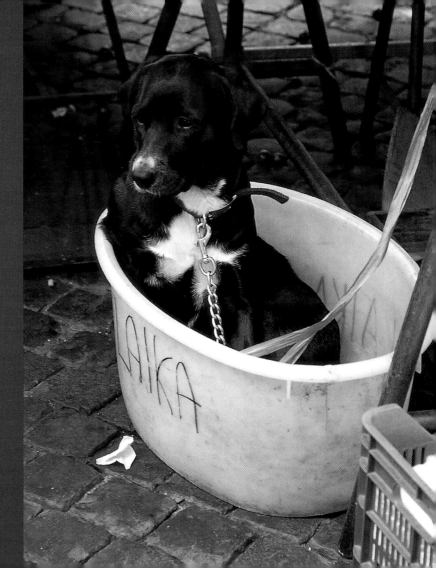

Gin + Maurizio

Sit in the sun

Sitting around! That's what these two handsome boys do. When the sun's out on the streets of Rome, so are Gin and Maurizio. No playing with them if you lack confidence (no problem for me, of course). Nothing like a labrador to keep a dog on his paws. Gin is so obedient, so calm, so well groomed, so smart – so labrador. No wonder they are at the top of the list of most popular dogs in the world. What a combination Gin and his companion Maurizio are. They always attract a crowd, mostly female – I like that – and they both love to eat, Gin especially. In fact, Gin eats everything and anything, like most labradors: a panini in the morning, home for pasta at noon and a gelato for late afternoon. Ah, *la vita*.

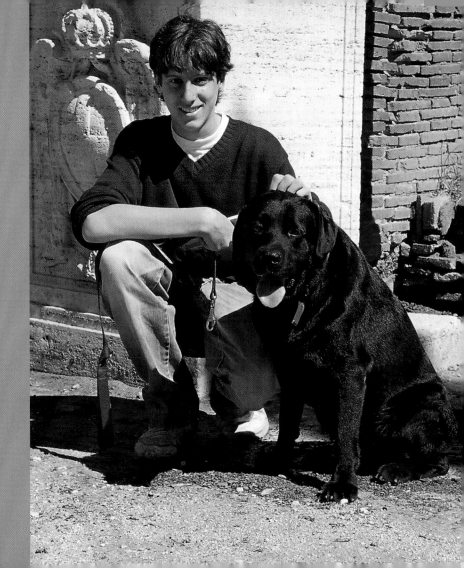

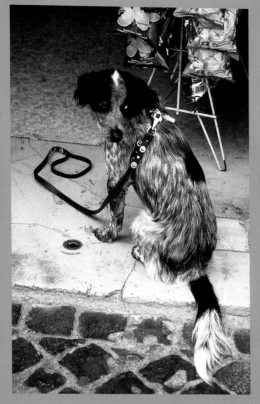

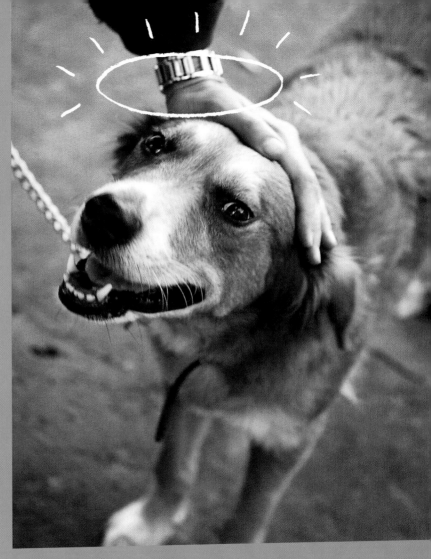

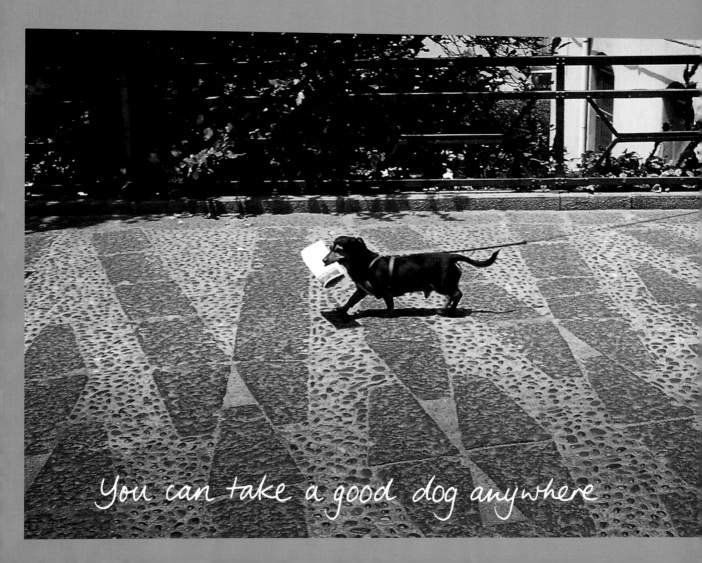

You can take a good dog anywhere

Carlotta + Maurizio

Amore, Amore, Amore

Just look at the way Carlotta and Maurizio look at each other. Carlotta, a prize poodle without a home, and Maurizio, considered one of the most artistic dog clippers in Rome, without a dog of his own. It was meant to be. She was for sale, he had to have her and that was that. The beautiful little white princess in the hands of the genius hairdresser – a match made in doggie heaven. Carlotta never minds the hours of brushing, clipping, pushing, pulling, drying and snipping. Maurizio grooms her with such love she could spend hours in his salon and stay for more. Oh, such love! That's *amore*!

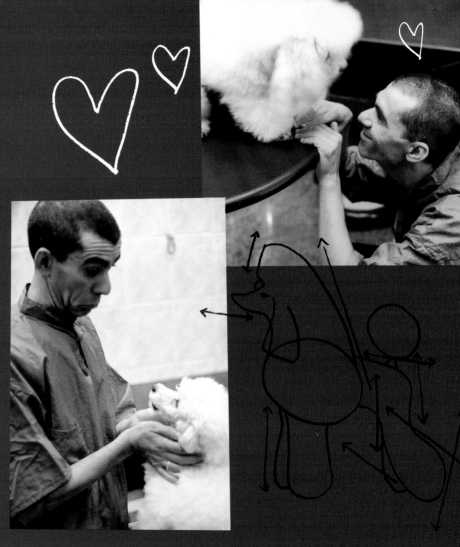

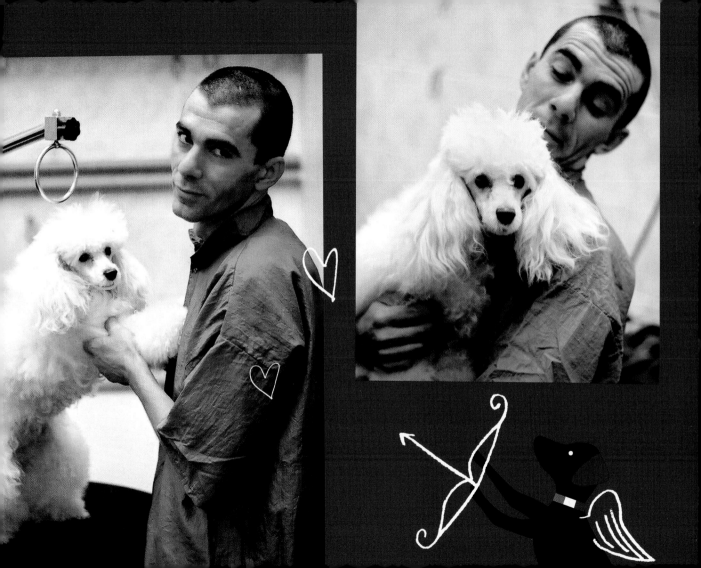

L'ACCESSO AI CAMPI
E' CONSENTITO SOLO
IN PRESENZA
DELL'ISTRUTTORE

TOELETTATURA
ER CANI E GATTI

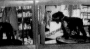

06 - 84240003
TEL.
0347 - 8754985

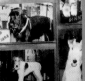

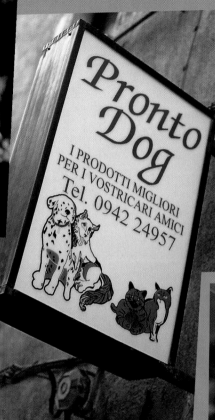

Pronto
Dog

I PRODOTTI MIGLIORI
PER I VOSTRI CARI AMICI
Tel. 0942 24957

IO NON POSSO POSSO ENTRARE

MOD 1129

Walter's

Articoli per animali - tosature - stripping

BARI - tel.080.5560525

4AF BA

Kangoo

COMUNE DI ROMA
SERVIZIO
GIARDINI

CAVE CANEM

'Come' is my favourite word. It means someone wants me for pats, for kisses, for playing, for walking. I always run when I hear 'come'. Yes, yes, yes, I think to myself. What do you have for me? What are we doing? I'm coming with you.

'Marco! Come!'

come
vieni

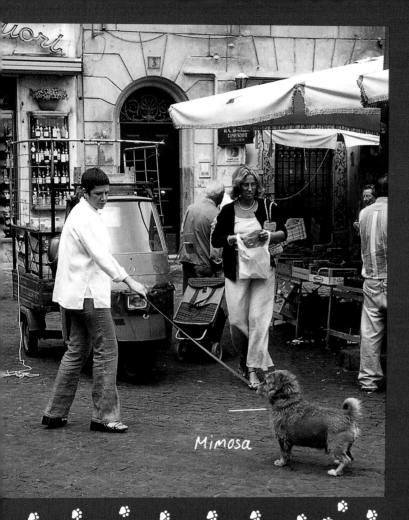

Mimosa

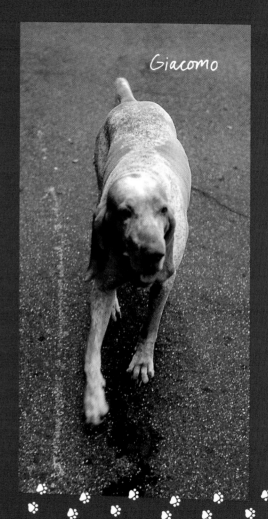

Giacomo

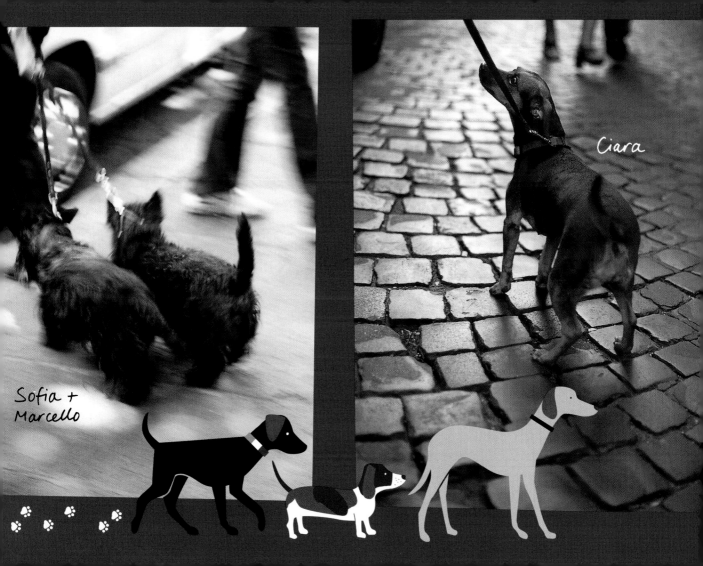

Ciara

Sofia +
Marcello

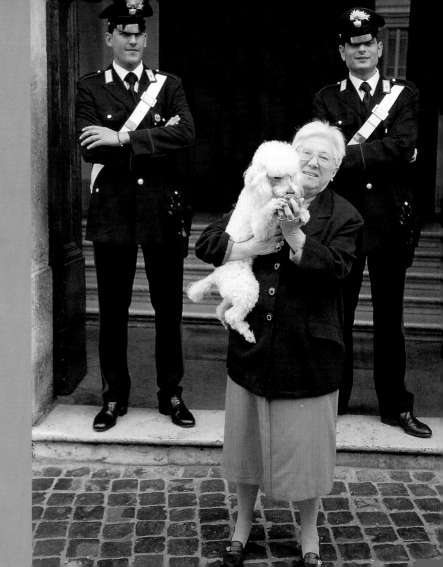

Mimi + Professor Limiti
come to the piazza and play

I first saw Mimi in the Piazza Navona. What a sight! A white, dazzling, delicious, dynamic, prancing poodle. Everyone is in love with Mimi. She's the mascot of some of Rome's most beautiful piazzas. Children, adults, tourists, shopkeepers and even the *carabinieri* (police) await her daily arrival. She's a star! However, Mimi only has time for her companion, Professor Limiti. They have a friendship that is the envy of many. No matter how many friends Mimi has and how much she loves to play, she never takes her eyes off the professor. They are never apart. One simple word from the professor – 'Come' – and Mimi is off running as fast as she can and jumping into the professor's arms. I do believe I'm jealous. Can I come too?

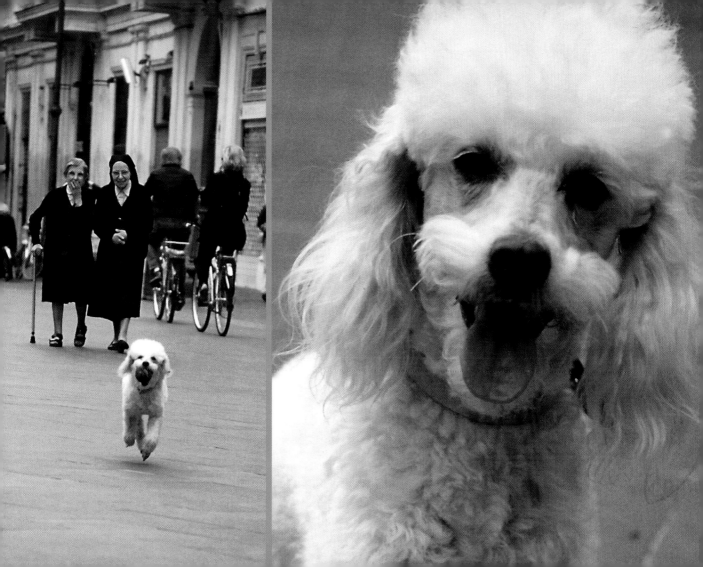

Akira + Federico

Come for breakfast

I ran into Akira in the Piazza del Popolo on my way to the park. Or should I say, Akira ran into me! I was minding my own business, having a sniff as dogs do, when all of a sudden I got stood on. A paw in my ear, a tail in my face and sat upon by all 55 kilograms of Akira, the Great Dane. I wish Federico, Akira's companion, had noticed me before he called Akira to come. It would have saved me the embarrassment of being bowled over, but then I wouldn't have met Akira. Akira is very obedient, and knows that if he is a good dog he can go to the cafe with Federico – and me. We both come running the minute he's bought breakfast – the smell, the taste! Akira always stands on his back legs and kisses Federico as a thankyou. Come – *Vieni* – let's eat breakfast.

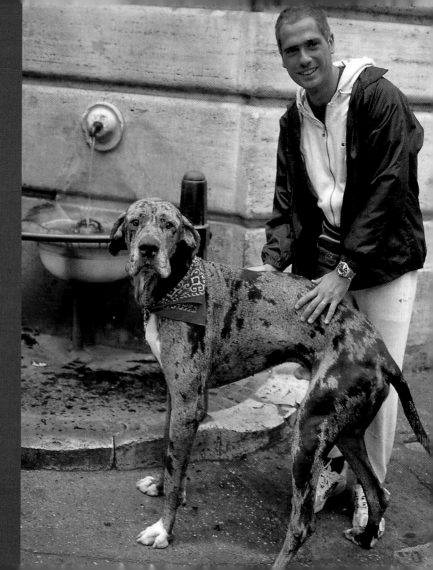

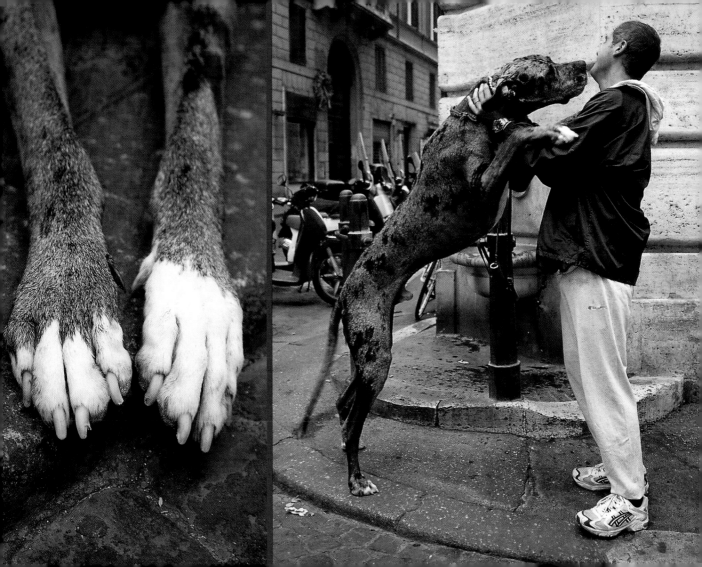

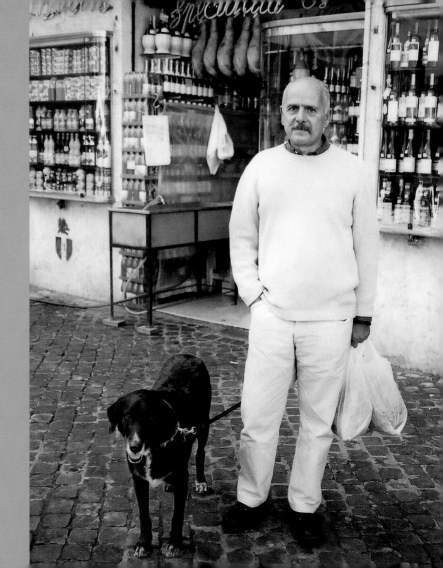

Cedro + Bruno

Come to the butcher's

Ciao Cedro! Cedro and I are old friends. Cedro's companion, Bruno, shops at the same butcher's as my companions. We've all been coming here for years. In fact, that's how we met. One day I thought I heard someone calling me from inside the butcher's. They wanted me to come inside, to the best prosciutto, salami, ham and bones in the world. I couldn't believe my luck. Just as I was about to burst through the doors a voice yelled, 'Sit and stay, Marco. Now!' I gripped the ground with my paws and slid to a stop. They weren't calling me. They were calling Cedro. In he walked, straight past me, to the butcher who presented him with a bone. Outside Cedro pranced around with his prize, then sat quietly and shared it with me. Now it's a tradition. Every market day Cedro waits to hear the butcher's command. In he goes to collect his bone and then comes straight back outside to me, waiting patiently. What a friend. *Grazie*, Cedro.

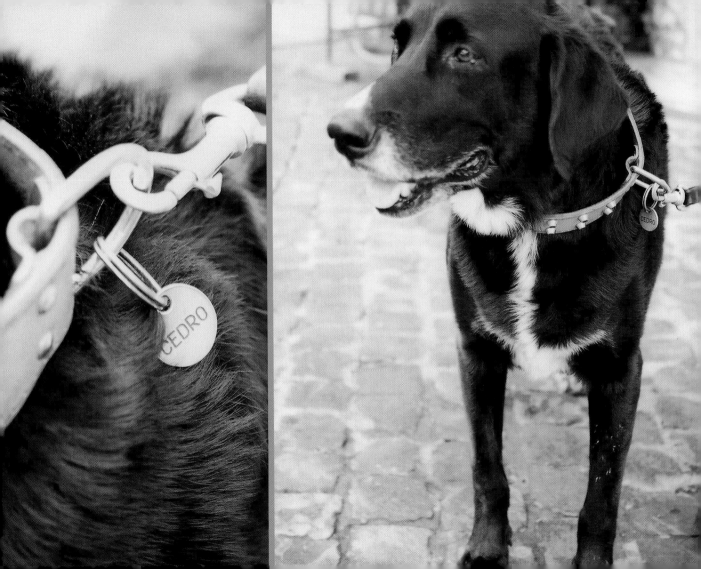

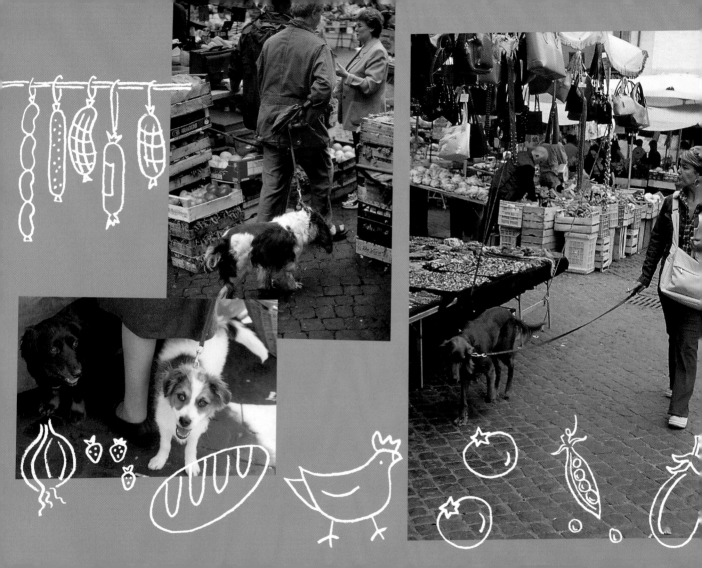

Toto + Graziella
Come to the market

Signora Graziella is Toto's best friend and mine. She's the housekeeper for Toto's companions. They live in Sicily. Toto's companions are in the travel business and always busy, so Signora Graziella runs their house. The signora is fun and generous and takes us everywhere. When she calls to us, we come running. 'Want to come to the market?' she always asks. 'Come, good dogs.' Leads and collars on, we're off. Toto and I love the market. A frenzy of smells! 'Come,' she calls and we follow her from one stall to the next. When she has found everything she needs, we are ready to go home and eat, eat, eat. Best of all, the signora is a superb cook. It's pizza tonight. Full of food, we sleep until we hear the signora call us in the morning: 'Come to the market.'

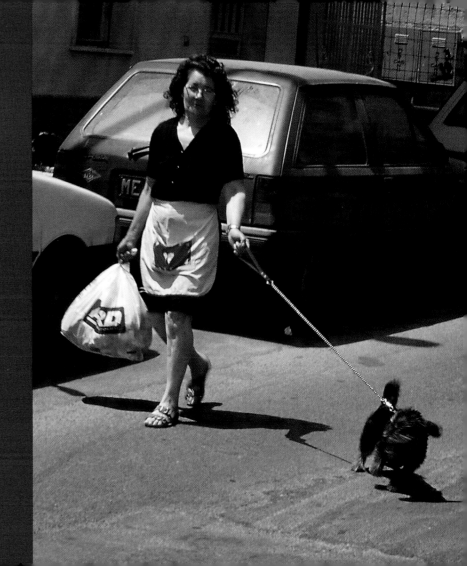

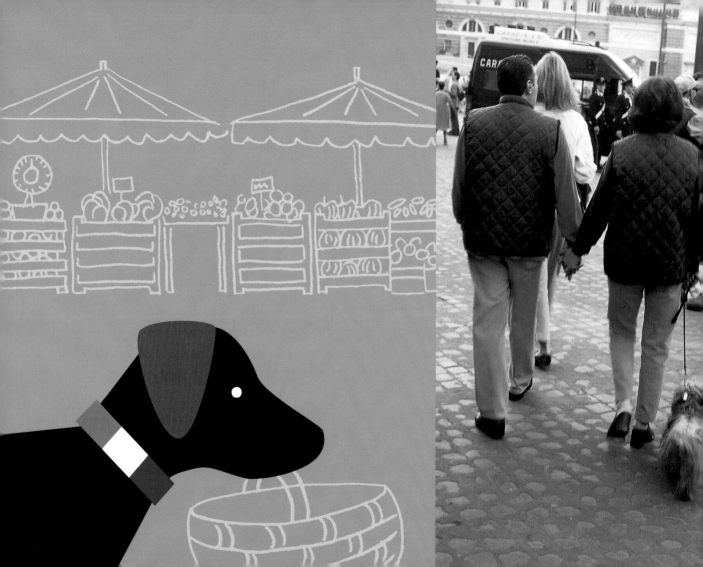

GRAZIELLA'S SICILIAN PIZZA

Let's go get it

For one 25 cm pizza

CRUST
3¼ cups plain flour
¼ cup polenta
¼ cup olive oil
1 egg
1 teaspoon baking soda
1 cup water
plain flour (for rolling)

TOPPING
½ cup tomato puree
2 garlic cloves, minced
1 small tin sardines in oil
1 teaspoon dried oregano
1 teaspoon dried rosemary
½ cup shredded low-fat mozzarella

1. Preheat oven to 180°C. To make the crust, mix all ingredients well in a bowl. Turn out onto lightly floured surface and knead until a smooth dough is formed. Cover and rest dough, refrigerated, for 15 minutes.

2. Roll out dough and place on a 25 cm pizza tray rubbed with olive oil. Bake for 15–20 minutes until crust just starts to brown. Remove from the oven and cool.

3. Spread tomato puree on pizza crust. Sprinkle garlic across pizza and crumble sardines evenly over crust. Season with oregano and rosemary and top with cheese.

4. Return to oven and bake for an additional 15–20 mintues until pizza is golden-brown.

5. Cool to room temperature and cut pizza into 8 slices. Store any unused portions in the refrigerator, covered.

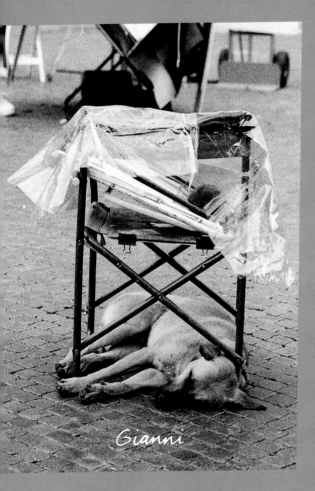

Gianni

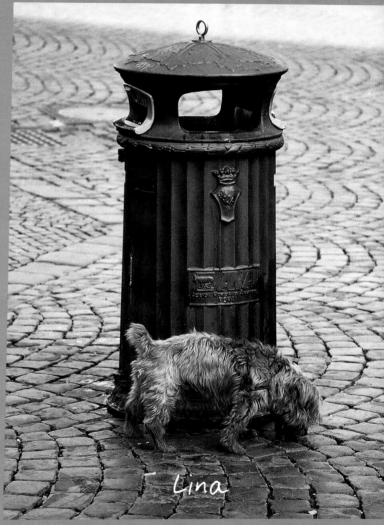

Lina

DOGGIE ZABAGLIONE

The dolci that dogs come running for

1 cup low-fat milk
1 egg
1 teaspoon honey
1 tablespoon fresh ricotta

1. In a mixing bowl, combine milk, egg and honey. Whisk vigorously until mixture is frothy and slightly thickened.

2. Pour into your dog's bowl and place a dollop of ricotta in the centre of the bowl.

To 'stay' for a dog like me – or any dog, really – is the most difficult thing to do. Imagine having to stay and wait while your companion is shopping and your doggie friends are playing in the park across the street. But stay a dog must. It has saved me many a time. You know how people drive in Italy...

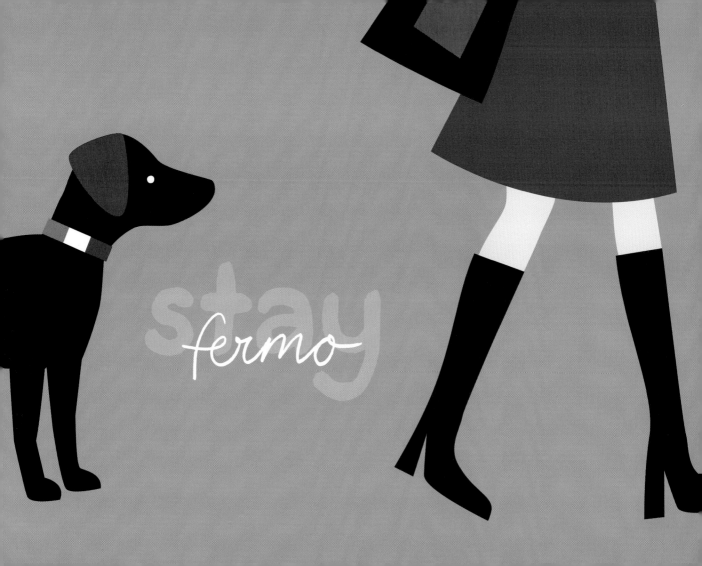

stay

fermo

Regina

Dandie

Benito

MACELLERIA

Beppe

Nerina + Schnitz with Manuela
Stay outside

There's nothing like having friends in the countryside. I always go to Frascati, about an hour from Rome, when the local festival is on. Nerina, the Belgian shepherd, and Schnitz, the German shepherd, are always waiting for me outside when I arrive. What a beautiful place to live, a big old house surrounded by an olive grove. Oh, the Italian countryside – cows, chickens, freedom to roam. Festival time in Frascati is always busy. Manuela cooks all day long. Dogs love to be inside, especially when there's food being prepared. When Manuela has had enough of the three of us constantly under her feet and looking for food, she takes control. 'Outside,' she commands. 'Stay outside,' and she means it. No wonder Nerina and Schnitz do what they are told. They love Manuela and their life in the countryside. I wish that I could stay, but the holiday is over and it's back to the city for me. *Arrivederci*.

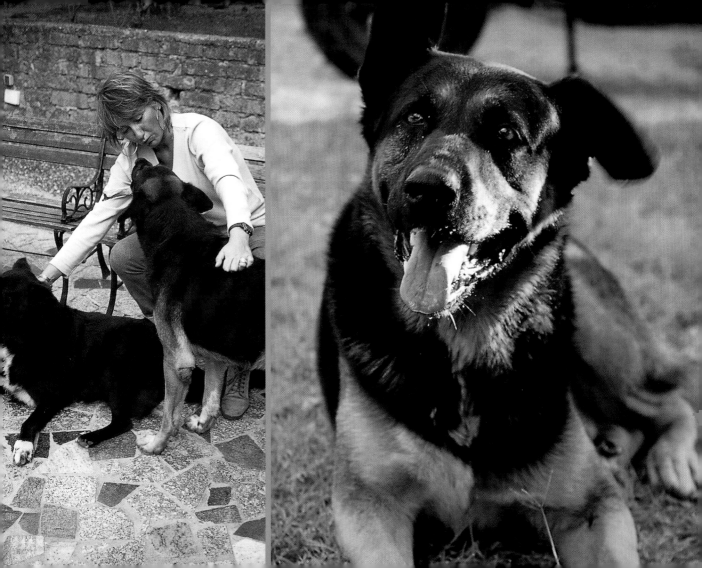

FRASCATI FESTIVAL PASTA AL Forno with Meatballs

Something for dogs to celebrate

Makes 4 servings

MEATBALLS
500 g lean ground beef
2 egg yolks
2 tablespoons freshly chopped or dried parsley
2 tablespoons freshly chopped or dried basil
2 garlic cloves, minced
½ cup dry breadcrumbs
1 cup cooked rice
pinch salt and pepper
olive oil (as required)

PASTA MIXTURE
500 g penne pasta, cooked al dente and cooled
2 tablespoons olive oil
400 g tin peeled tomatoes, chopped
250 ml water
1 garlic clove, minced
1 teaspoon dried oregano
2 cups shredded low-fat mozzarella cheese

1. To make the meatballs, combine all ingredients in a bowl and mix thoroughly. Place in the refrigerator, covered, for at least an hour.

2. Preheat oven to 180°C. Moisten hands and roll beef mixture into egg-shaped balls, approximately 4 cm long and 2 cm wide. Place on a baking sheet rubbed with oil.

3. To make the pasta mixture, place all ingredients in a bowl, except 1 cup mozzarella, and mix thoroughly.

4. Preheat oven to 180°C. Add the meatballs to the pasta mixture, mixing together. Transfer pasta and meatballs to an ovenproof casserole ensuring meatballs are spread evenly through the pasta mixture. Cover with aluminium foil and bake for 30 minutes.

5. Remove foil and spread reserved cup mozzarella evenly over the pasta mixture.

6. Bake uncovered for an additional 15 minutes. Cool to room temperature and serve. Refrigerate remainder and bring portions to room temperature before serving.

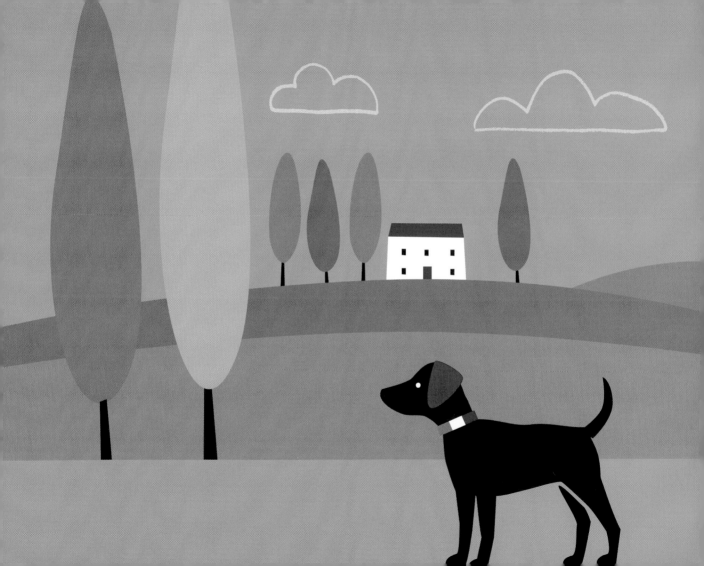

Willy + Rudy

Stay! Don't cross the road

'Stay' is one of the most important words a dog can learn. It can save your life. This story is a perfect example. One day I saw a very old, mixed-breed dog wandering around the park at Castel Sant'Angelo in a daze. He was obviously lost. Then I saw he was trying to cross one of the busiest streets in Rome. I shut my eyes. Suddenly a stranger called 'Stay!' in the loudest voice. The lost dog knew his stuff. He stopped the instant he heard the word and waited for the person who had called him to catch up. A miracle indeed. It turned out Willy really was lost and the strange voice came from Rudy, a tourist from Germany. They became instant friends. Now Willy is lost no more. Rudy is taking him home with him to Germany, but they promise to visit me soon. *Ciao* for now, Willy.

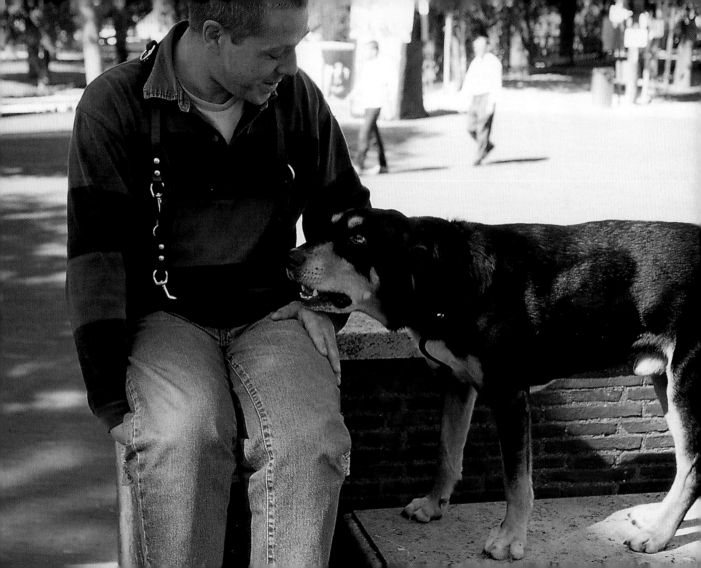

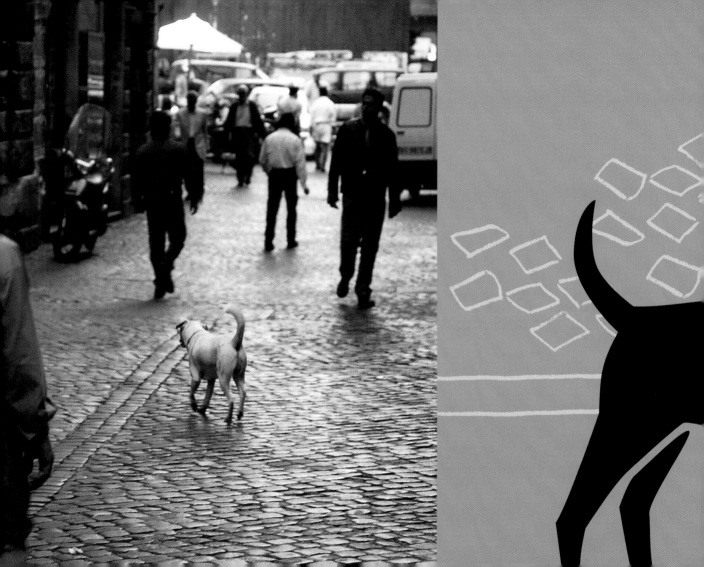

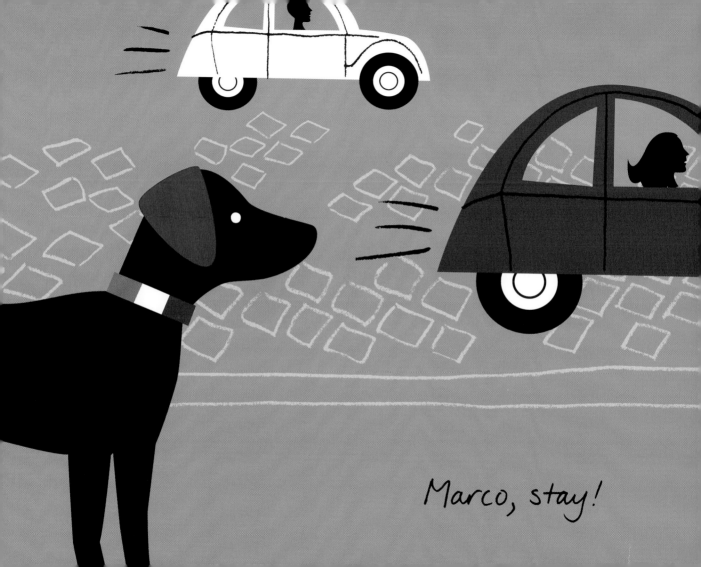

Marco, stay!

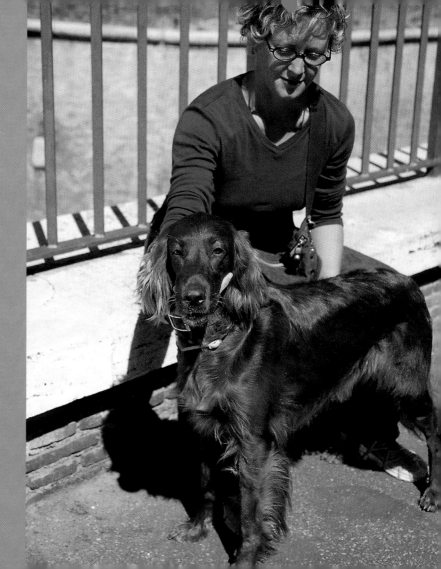

Vic + Raffaela
Stay – because I say so

Vic is a great friend of mine. She walks every day in the park at Castel Sant'Angelo with her companion Raffaela. No dog could miss seeing Vic, with that blaze of red hair, her elegance and breeding, but there's not a snobbish bone in her body. She's a pedigree dog and is always training for dog shows. Raffaela and Vic both know how important it is to stay perfectly still while the judges inspect Vic to ensure her breeding. Just look how she stays when Raffaela tells her to. She's a star. *Brava!*

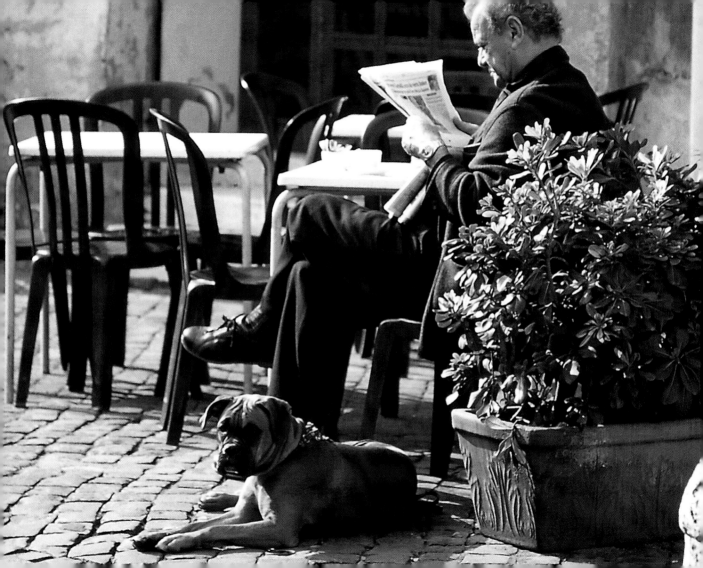

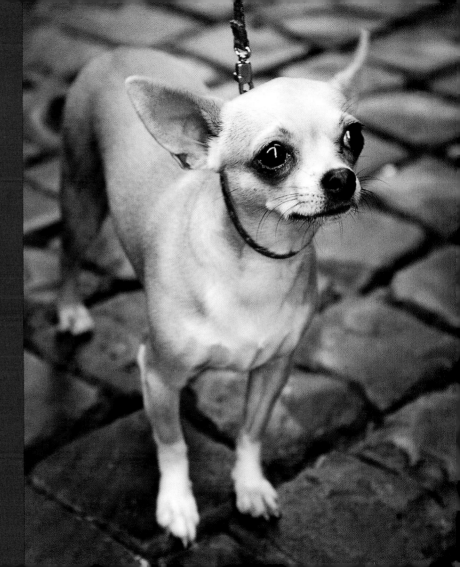

Toni

Stay - while I go shopping

Meet 'Tough Toni'. Well, that's what I call
him. He's one of my favourite friends. He's
small and he worries a lot. You see, his
companion loves shopping and Toni is
always told to stay outside shops and
wait. He stays but he worries. He hates
being left. The minute his companion
disappears inside the shop, it starts. First
he whimpers, then he starts to shiver and
he can't stop until his companion returns.
'Stay' is tough for Toni!

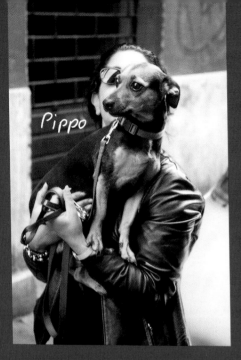

Pippo

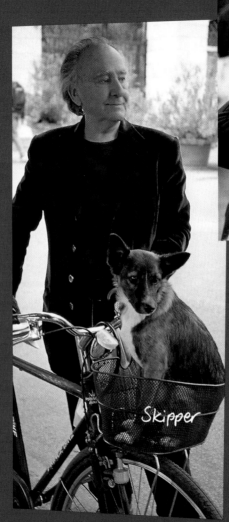

Skipper

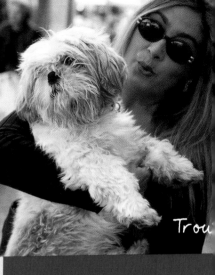

Trou

Guid

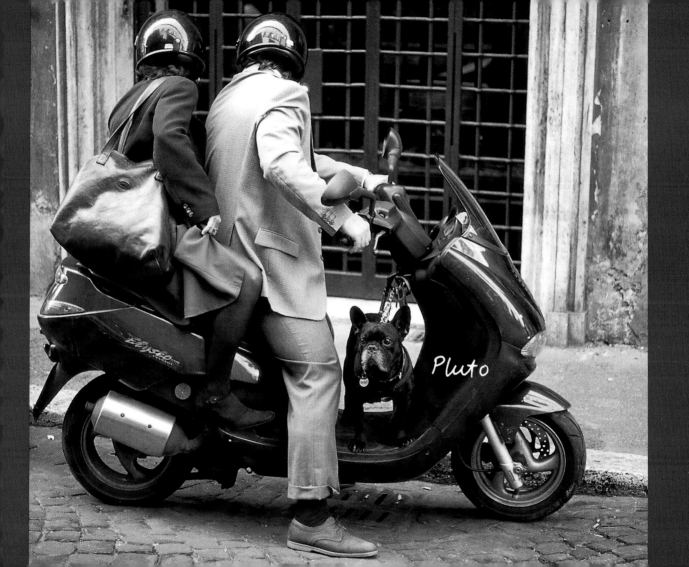

Pluto

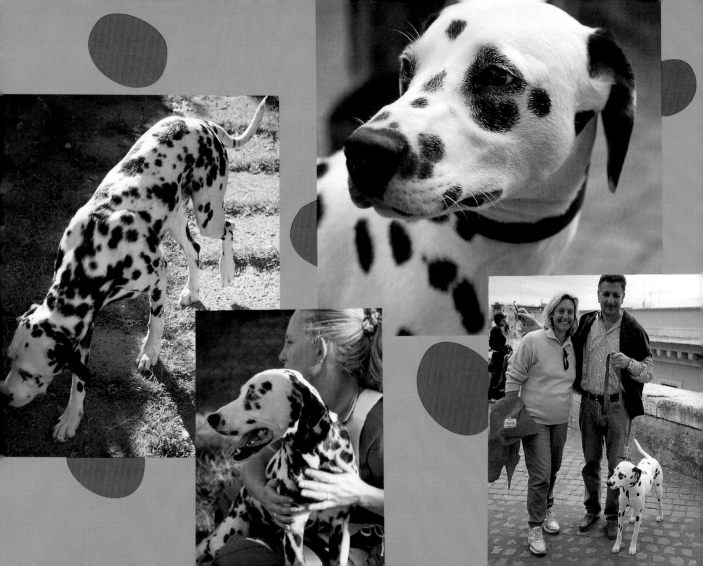

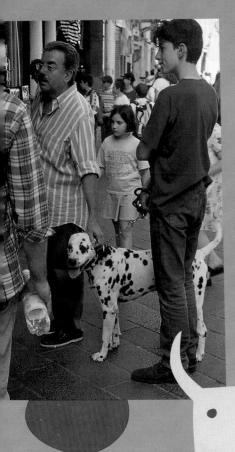

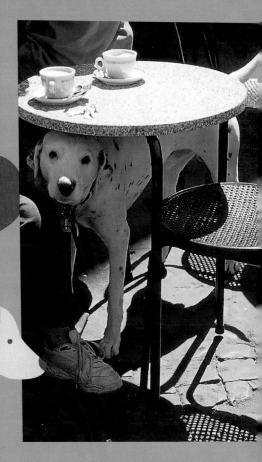

One hundred and two dalmations

'Let's go.' This isn't just being told what to do; this is music to a dog's ears. It's so exciting. I try to guess where we are going. I watch – okay, the lead is out – maybe it's the park. Oh look, the car keys are out – we are going for a ride. Sunhat, bucket and spade – I know, we're off to the beach. Really, I don't care where I go as long as it's out and about. Let's go – Andiamo. Now!

let's go
andiamo

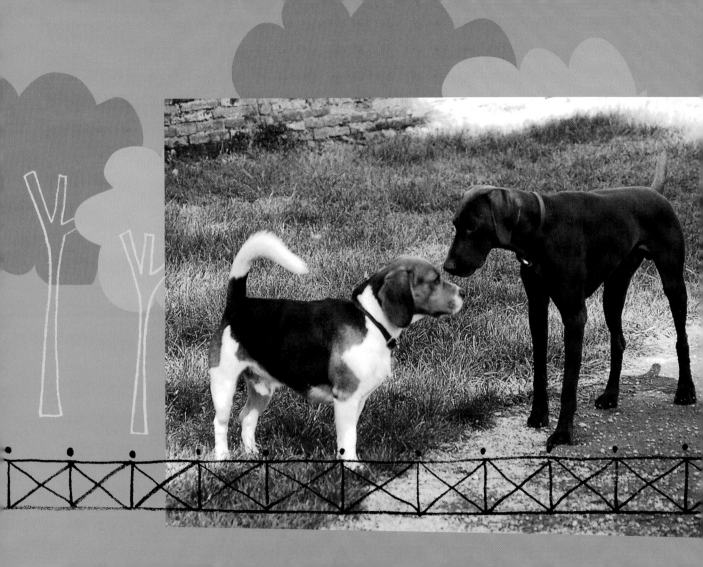

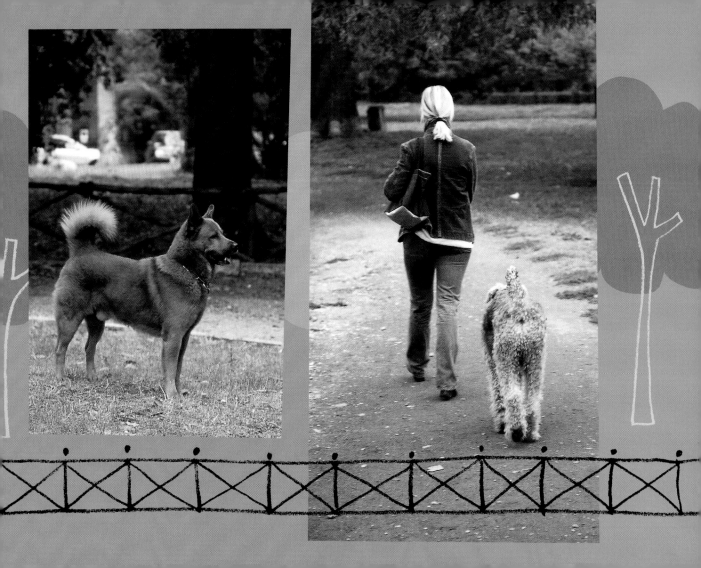

Stone + Perela

Let's go to the park

Buongiorno! It's morning. Time to go for a walk. I wait patiently for the words. Yes! My companions are dressed and here it comes – 'Let's go.' *Andiamo!* I'm ready, lead in mouth, and we're off to the park. My early-morning friends are Stone, the newfoundland, and Perela, the Yorkshire terrier. Big and Little, that's them. Giant Stone, gentle and quiet, and mini-sized Perela, non-stop bouncing and barking. They are so funny. Perela goes mad for her ball and Stone just quietly hides the ball in his mouth. It's chaos. Our park is called the 'Valley of the Dogs', which is perfect for us. It's near a zoo, so it smells and sounds wondrous. We wish our walk would never end. But our companions can't play all day, and eventually it happens; they call, 'Let's go.' *Andiamo a casa*. Time to go home for breakfast and a doggie nap.

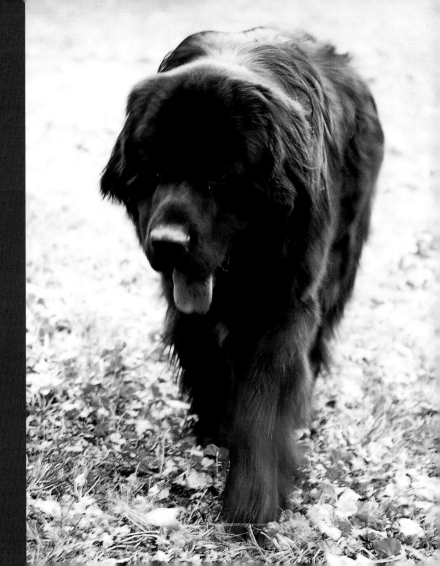

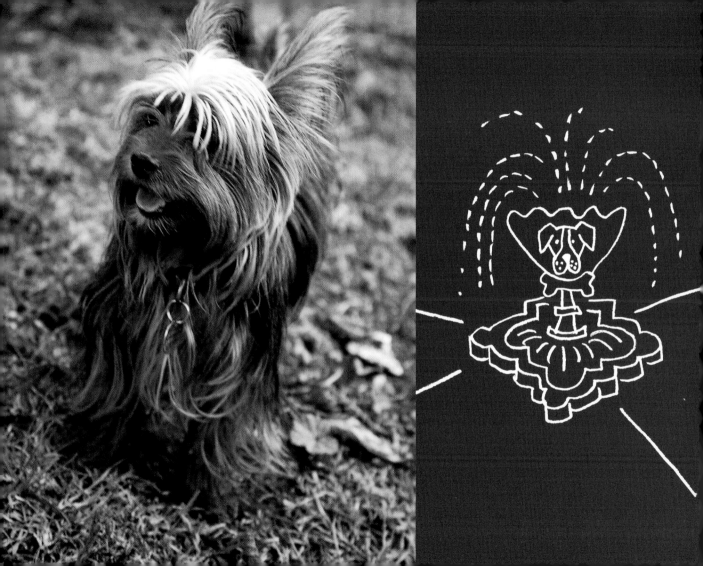

Karli + Schif with Rosalba

Let's go play soccer

Every dog loves a ball, but these two friends are serious. They play big ball, soccer in fact, and they play rough. Karli is a doberman and Schif an alsatian. They play hard, but they play fair. It's all due to their loving companion, Rosalba. She's amazing. Both Karli and Schif were homeless dogs. Rosalba has loved them, trained them and even cooked health food to help them become happy dogs. And they are! Some of my doggie friends are afraid of these big dogs, but I think they are perfect. Anyway, let's go play soccer while the ball still has air inside. Oops. Someone's big tooth has made a hole in it ...

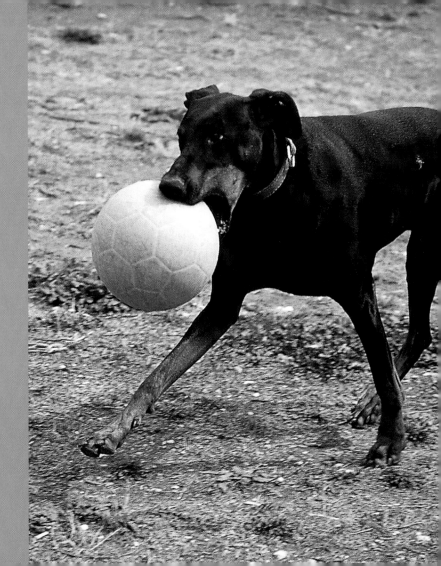

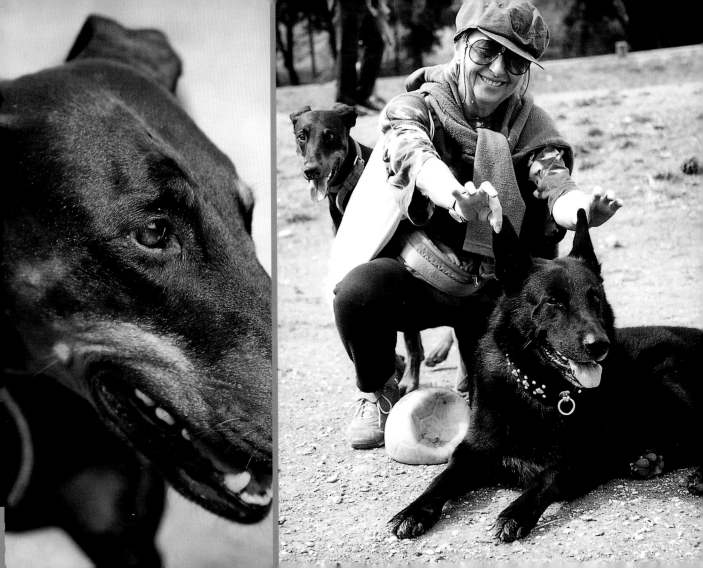

DOGGIE MINESTRONE
That's the go

Makes approximately 2 litres

400 g tin chickpeas
2 tablespoons olive oil
2 garlic cloves, minced
½ cup peeled and diced carrot
½ cup sliced asparagus
½ cup sliced green beans
½ cup diced zucchini
1 potato, peeled and diced
3 tablespoons tomato paste
6 cups water
8 fresh basil leaves, finely sliced
2 cups small pasta shapes, such as fusilli, macaroni or orzo

1. Drain and rinse the chickpeas.

2. In a pot large enough to hold all the ingredients, heat olive oil. Add garlic and sauté for 3–4 minutes.

3. Add carrot, asparagus, green beans, zucchini and potato and cook for 5 minutes, stirring occasionally.

4. Add tomato paste, chickpeas, water and basil. Bring to a boil, then simmer, covered, for 30 minutes or until vegetables are tender.

5. Add pasta and continue to simmer for 8–10 minutes until pasta is well cooked.

6. Let cool and serve. Refrigerate the unused portion for future meals.

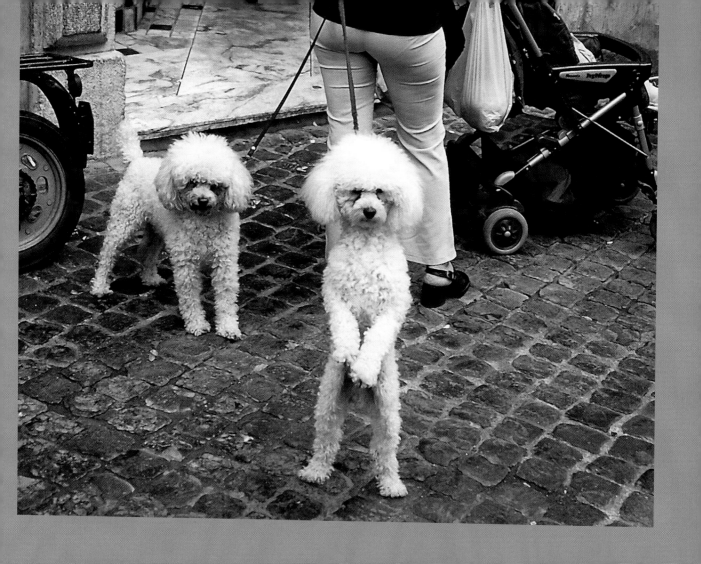

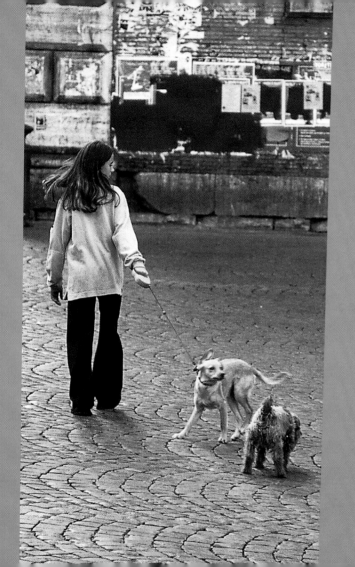
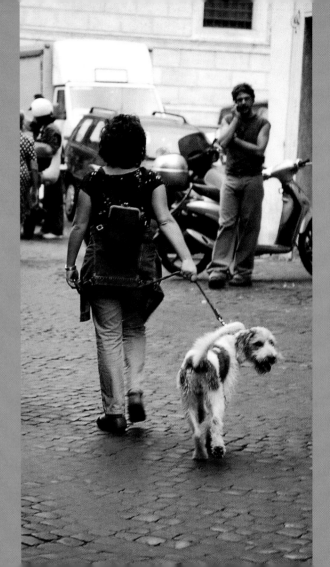

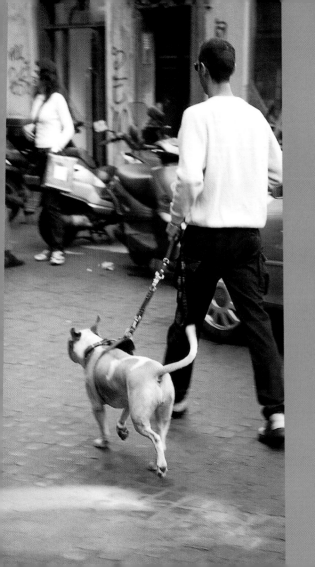
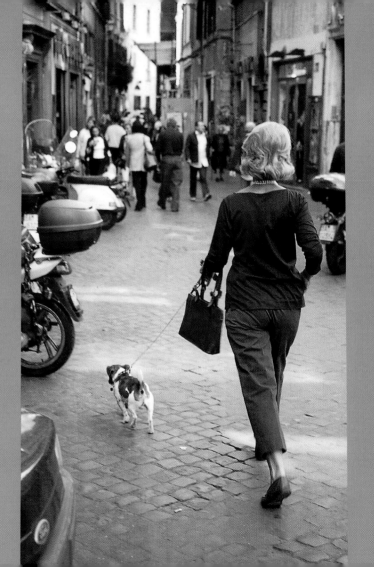

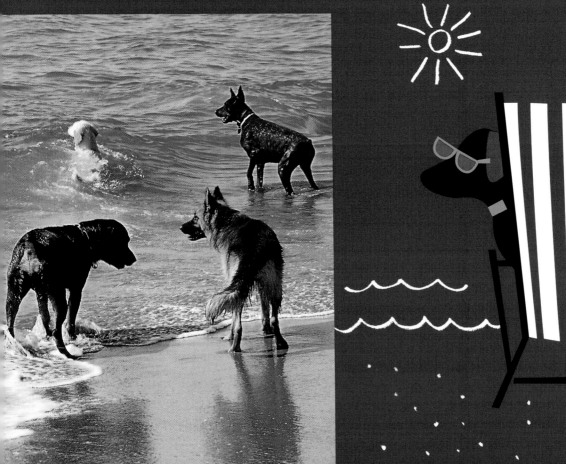

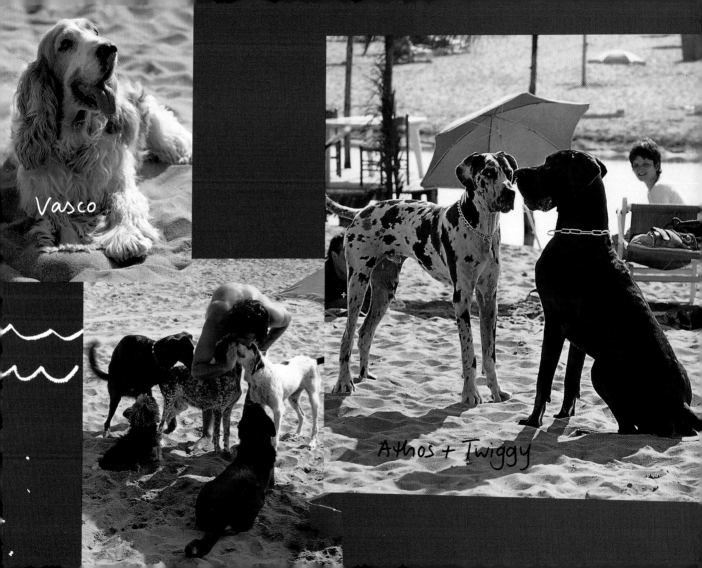

Vasco

Athos + Twiggy

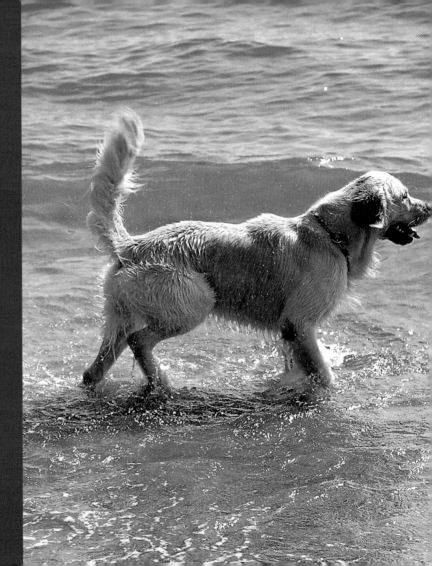

X, Big + Alessandro

Let's go swimming

Water, sun, swimming, fun. I love the beach, and outside Rome is the perfect place for a dog to go swimming. This is Beaubeach, a beach just for dogs and their companions. The first beach dog I met was X (pronounced 'ix'), a perfect specimen of a rottweiler if there ever was one. (I love a rotti. My current girlfriend is a rotti. Oh, is she gorgeous; athletic body, huge forehead, long pink tongue ...) Anyway, X and his companion, Alessandro, a tall, tanned, muscular Roman, make me, Medium Marco, feel quite small. It gets worse. Big, the golden retriever, is X's best friend. These two can swim, and they've been coming here for years. So into the water we go and things go wild. Jumping, barking, splashing and diving for beach balls – and all the time I try to stay afloat. I'm not a good swimmer. Even the dog paddle doesn't help me. Help! I'm soaked! I need resuscitation! Wait, stop, I'm hysterical. It's okay. I can do the beach thing and be cool and Italian. But I am very, very wet and I did drink a lot of very salty water. *Andiamo*. I need to sunbake.

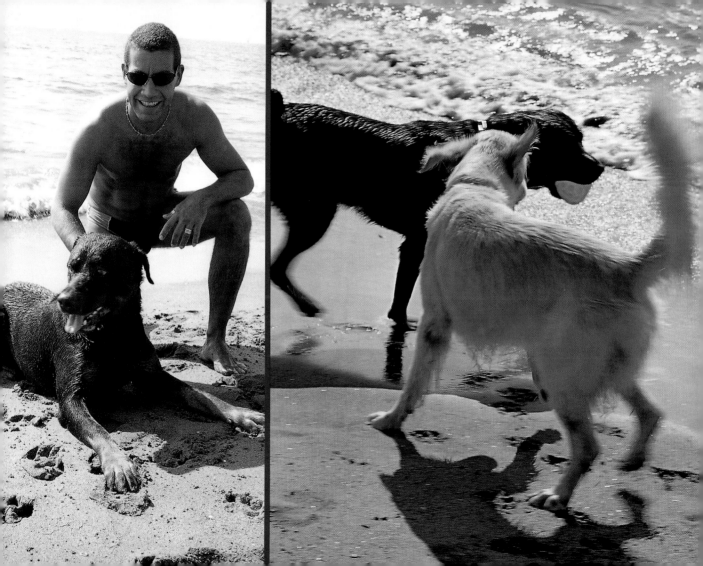

Luna + Gina

Let's go sunbake

Oh, thank goodness for Luna, the Neapolitan mastiff, born and bred in Naples, a true Italian dog. No imported blood lines here. Hard to imagine that this gentle giant, weighing 60 kilograms, could have been threatened with extinction only fifty years ago. Anyhow, Luna became my constant companion at Beaubeach and we promised to be friends forever. Despite her size, she has perfect manners and prefers to observe rather than swim. Luna is a real Italian girl, a poser and thankfully not a swimmer. *Brava* Luna, my lifesaver.

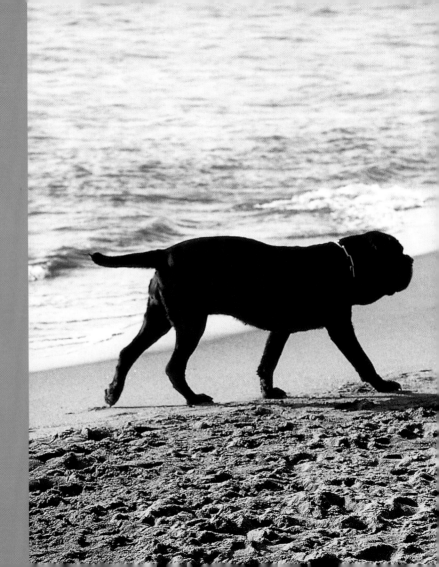

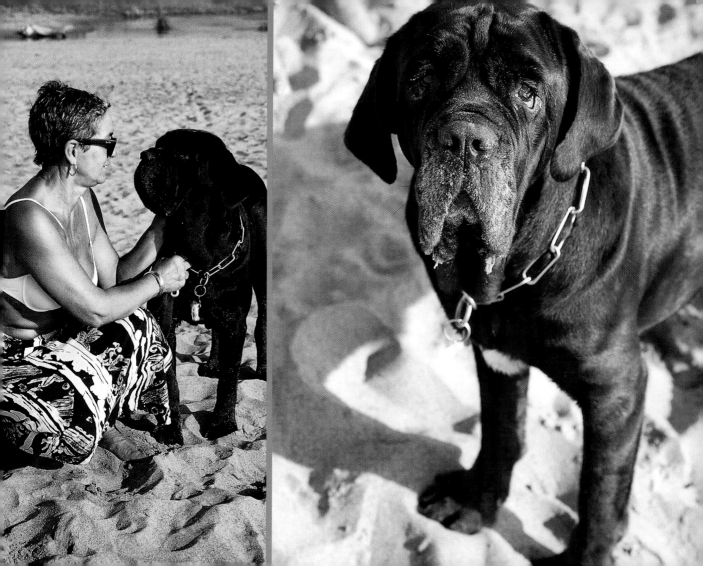

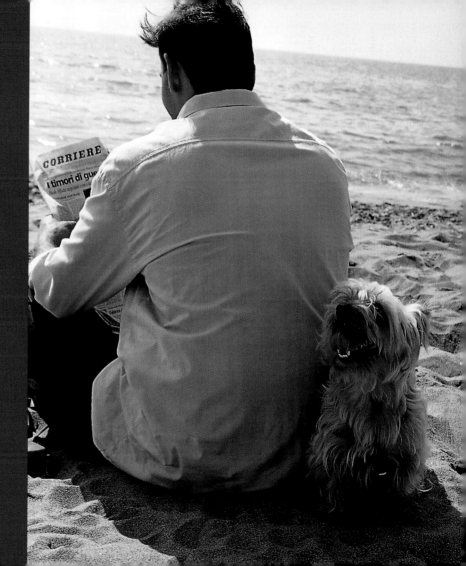

Tsasko + Simone

Let's go sit in the shade

Tsasko, the Yorkshire terrier, was only at the beach for the day. Such a shame – a small beach-lover at last, even smaller than me. Tsasko was fun, and free to roam the beach without her companion, Uncle Simone. Simone was babysitting Tsasko and very embarrassed to be seen with such a little dog. Well, some people just don't get it. We smaller dogs are the smart ones. No swimming for us. We just sit in the shade, looking cute and watching all the girls go by. *Andiamo*. Let's go find another shady spot.

The Digging Dog
Let's go dig a hole

I'd like to finish my seaside holiday by introducing you to the Digging Dog. I never did get to meet him really and I don't know his name. I just watched every day as he happily dug deeper and deeper into the sand, completely content. I loved watching the Digging Dog; the waves, the water and the sun going down over Beaubeach and him disappearing into his hole with it.
Andiamo – let's keep digging.

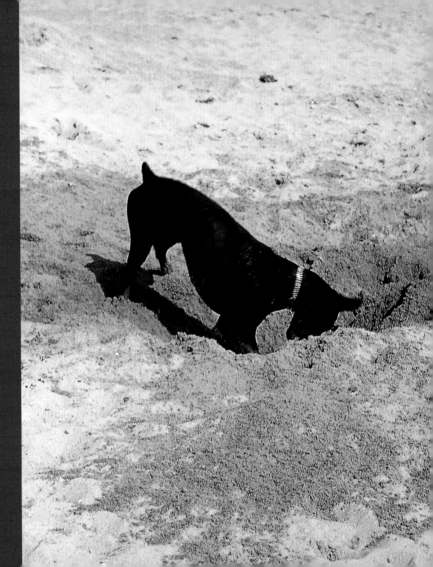

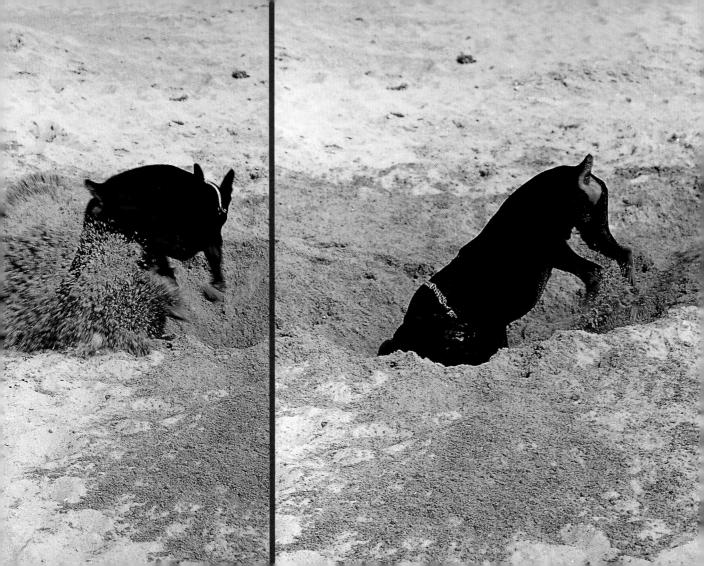

Picasso + Claudio
Let's go to the Salon

Claudio is a natural; he loves dogs perhaps even more than he loves people. He worked in a dog salon for many years and eventually got the chance to open his own. He is gentle and kind, his voice relaxes you and his hands make you feel calm. He has a way with shampoo, hairdryers and combs that is rare for a dog groomer. Here is my friend Picasso – before and after. *Che bello*!

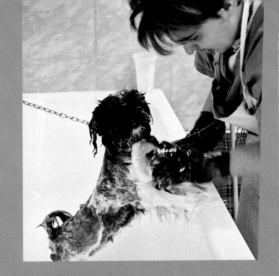

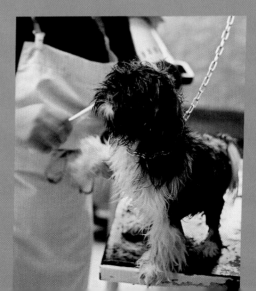

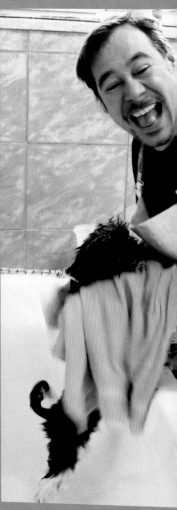

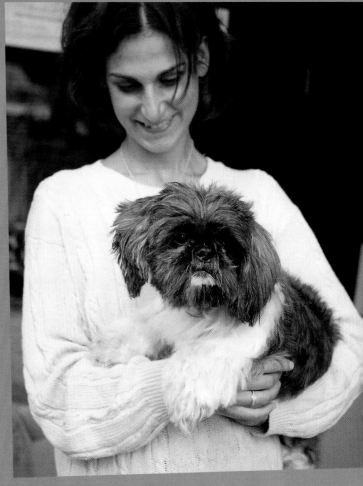

MARCO'S TRAVEL HINTS

- My companions never leave me in the car alone. Even on a cloudy day, doggies dehydrate in minutes.

- Make sure your dog is confined or wearing a proper doggie seatbelt in the car. Doggies don't have hands; we can't hang on.

- Take a lot of breaks. I love a garage stop – it's a chance to stretch my paws and do what dogs do. Remember to have a bag on hand, please.

- Pack plenty of water. My companions have one of those cool fold-up water bowls so I don't get thirsty on the road.

- Pack some toys from home and your doggie's favourite blanket to sit on in the car. Then we can sleep in peace.

- Don't feed your dog before you leave on a driving holiday. A full tummy and a long car trip don't work for us.

- If your doggie gets carsick or is looking a little green, stop for some fresh air and try a cone of vanilla ice-cream (it really works!).

- Even when they take me on holiday, my companions make sure my diet stays the same. Doggies take a little time to settle into new surroundings and strange food can cause unnecessary tummy trouble.

- When you arrive at your destination you need to be on guard. We can't resist snooping around, so make sure we can wander safely. Move any tempting objects and look out for strange poisons for rodents or snails – very dangerous.

- My final hint – a real must. Give your doggie plenty of love and you'll be amazed what you get in return – Marco knows!

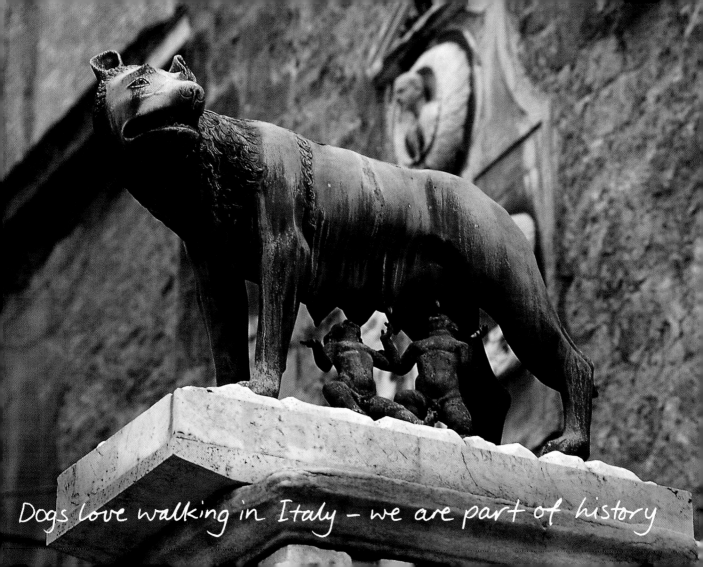

Dogs love walking in Italy - we are part of history

Venice

The Leaning Tower of Pisa

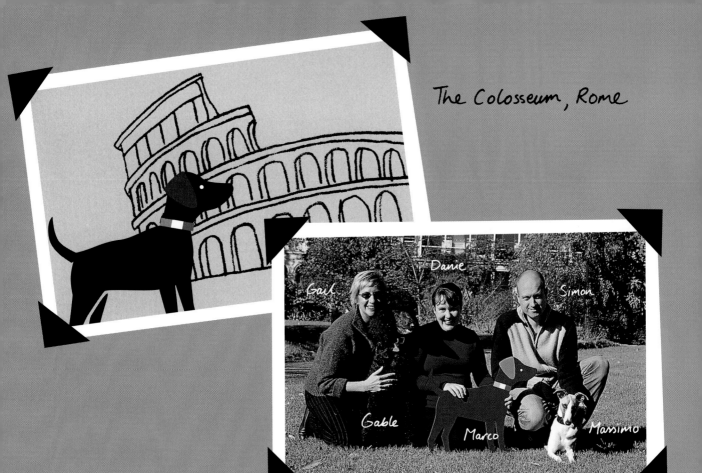

The Colosseum, Rome

Gail
Danie
Simon
Gable
Marco
Massimo

Friends and Companions

Viking
Published by the Penguin Group
Penguin Books Australia Ltd
250 Camberwell Road, Camberwell, Victoria 3124, Australia
Penguin Books Ltd
80 Strand, London WC2R 0RL, England
Penguin Putnam Inc.
375 Hudson Street, New York, New York 10014, USA
Penguin Books, a division of Pearson Canada
10 Alcorn Avenue, Toronto, Ontario, Canada M4V 3B2
Penguin Books (NZ) Ltd
Cnr Rosedale and Airborne Roads, Albany, Auckland, New Zealand
Penguin Books (South Africa) (Pty) Ltd
24 Sturdee Avenue, Rosebank, Johannesburg 2196, South Africa
Penguin Books India (P) Ltd
11, Community Centre, Panchsheel Park, New Delhi 110 017, India

First published by Penguin Books Australia Ltd 2002

10 9 8 7 6 5 4 3 2

Design by Danie Pout
Typeset in Helvetica Neue Light
Colour separation by Splitting Image
Printed and bound in Singapore by Imago Productions

National Library of Australia
Cataloguing-in-Publication data:

Donovan, Gail.
 Walking the dog in Italy.

 ISBN 0 670 85819 6.

 1. Dogs – Italy. 2. Dogs – Italy – Pictorial works.
 3. Italy – Description and travel. I. Griffiths, Simon.
 II. Pout, Danie. III. Title.

636.70945

www.penguin.com.au

Where are we going next, Marco